# INSIDE SCOTTISH
# FOOTBALL

PHOTOGRAPHS FROM THE JIM RODGER COLLECTION

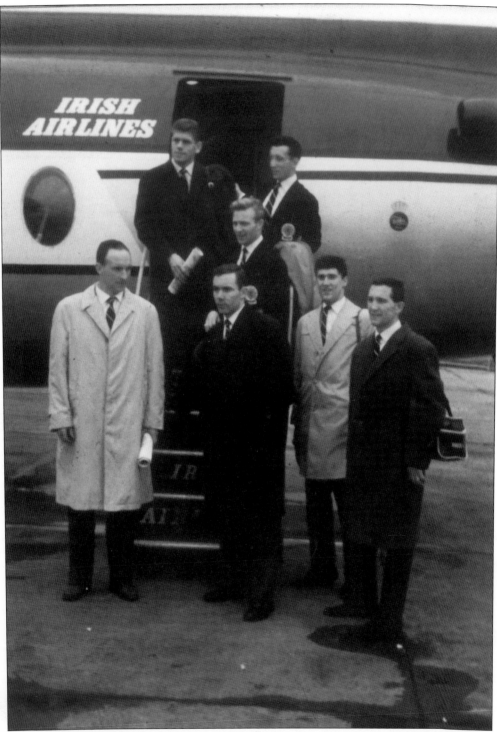

The Scotland squad flying to Ireland in 1961. From left to right, back row: Leslie (Airdrie), McLeod (Hibs), Wilson (Rangers). Front row: Ian McColl (manager), McKay (Celtic) Baxter (Rangers), Brand (Rangers).

# INSIDE SCOTTISH FOOTBALL

## PHOTOGRAPHS FROM THE JIM RODGER COLLECTION

## TOM PURDIE

*This book is dedicated to Jim's widow, Cathie, daughter, Joyce, son-in-law, Bill McMunn, and grandsons, Scott and Lee.*

TEMPUS

First published 2001
Copyright © Tom Purdie, 2001

Tempus Publishing Limited
The Mill, Brimscombe Port,
Stroud, Gloucestershire, GL5 2QG

ISBN 0 7524 2233 2

Typesetting and origination by
Tempus Publishing Limited
Printed in Great Britain by
Midway Colour Print, Wiltshire

Present and forthcoming titles from Tempus Publishing:

| | | | |
|---|---|---|---|
| 0 7524 1860 2 | Aberdeen FC: Images | Paul Lunney | £9.99 |
| 0 7524 1565 4 | Celtic FC 1887-1967: Images | Tom Campbell & Pat Woods | £9.99 |
| 0 7524 2230 8 | Dundee FC: Images | Paul Lunney | £10.99 |
| 0 7524 1560 3 | Heart of Midlothian FC: Images | Heart of Midlothian FC | £9.99 |
| 0 7524 2170 0 | Hibernian: Images | Paul Lunney | £10.99 |
| 0 7524 1511 5 | Motherwell FC: Images | John Swinburne | £9.99 |
| 0 7524 2191 3 | Motherwell FC: Players Directory | Jim Jeffrey & Genge Fry | £15.00 |
| 0 7524 1686 3 | Queen of the South FC | Ian McDowell | £9.99 |
| 0 7524 2217 0 | The Ultimate Drop | George Rowland | £12.99 |
| 0 7524 1855 6 | Football Programme | John Litster | £12.99 |
| 0 7524 1851 3 | The Five Nations Story (hb) | David Hands | £18.99 |
| 0 7524 2229 4 | Speedway in Scotland | Jim Henry & Ian Moultray | £14.99 |
| 0 7524 2210 3 | Homes of Speedway | Robert Bamford & John Jarvis | £17.99 |
| 0 7524 2166 2 | A False Stroke of Genius: The Wayne Larkins Story | John Wallace | £12.99 |
| 0 7524 2167 0 | Lord's: Cathedral of Cricket (hb) | Stephen Green | £25.00 |
| 0 7524 2209 X | Famous Golf Postcards | Graham Rowley | £10.99 |
| 0 7524 2218 9 | Harry Vardon | Audrey Howell | £14.99 |
| 0 7524 1812 2 | St Andrews Golf | Stuart Marshall | £9.99 |

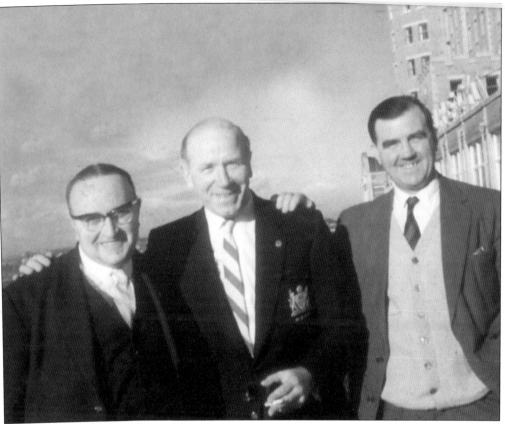

Jim with Matt Busby and Jimmy Carrabine.

# Acknowledgements

My thanks to Alex Cameron of the *Daily Record*, the late Jim Baxter, Sir Alex Ferguson, former Celtic player David Cattenach, my neighbour Billy Taylor, Bob Laird for encouraging me to compile the book and finally my wife, Grace, for her patience.

# Foreword

Jim Rodger was an outstanding journalist as well as a good friend. He had an incredible network of contacts in a wide range of professions – football, politics, and the Church – but never misused his influence.

Jim was always there to help others and looked for nothing in return. He was devoted to football and took a tremendous interest in young players, following their careers and advising their families.

In his journalistic travels, Jim loved to take snaps and many of these are reproduced in the following pages. Jim's picture album will hopefully bring back many memories to players, sports-writers and supporters.

Sir Alex Ferguson

# Introduction

If Jim Rodger were alive today, he would make a fortune as one of the most popular agents dealing in major soccer transfers. He would be discrete and honourable at all times, and could have taught the wheeler-dealers some lessons in the delicate art of honesty and keeping clubs and players happy.

In the 1950s and '60s, Jim was football's Mr Fixit – a shadowy figure behind the scenes in some of the biggest player and managerial moves. But all he wanted was the exclusive story and, to the annoyance of his rivals, he frequently got it. It was routine for sports writers to act as middlemen in those days, but the leading fixer was undoubtably Jim: rotund, cheery and happy to be called 'the wee man from Shotts'. He would have been an unlikely James Bond character, although he had enough genuine mystery about him to have been in Sean Connery's 007 team.

Jim wasn't a flowery writer, but he created more back-page headlines than any of us for at least half a century. Despite the fact that he was so well known, he was a very private person and wasn't best pleased when an editor put a giant picture of him on the back of Glasgow Corporation buses. Sir Robert Kelly, the late Celtic chairman, kidded that he could no longer call himself 'Wee Jim – the boy from the country'. He bristled at this, but carried on as he always did. He lived much in the style of an ex-miner, in a semi-detached house in Shotts – where Rangers director Ian Skelly and most others in Lanarkshire appropriately knew him as 'Scoop'.

He graduated from the coal-faces, but transferred his remarkable and flexible talents to journalism because of an injury. He went on to hack his way to the top in the Fourth Estate sporting arena. He scented stories like a bloodhound and his pursuit was every bit as relentless. Despite this, or maybe because of it, Jim was liked, respected and even feared. He amassed an amazing array of highly-placed friends, in politics and the police as well as football. His link with the players began at schoolboy level. He made a point of finding out where the lads lived and their telephone numbers, so that he could talk to their parents, or even grannies, if necessary.

It was no surprise and generally applauded when he was awarded the OBE in 1989 for his charity work and journalism. Nobody before or since has had so many ex-directory contact numbers in his or her contacts book. For example, when Harold Wilson was at 10 Downing Street, Jim – a lifelong Labour supporter – had a hotline to the Prime Minister's desk. I know this because he dialled the number in my presence and let me speak to the gravel-voiced PM, who was neither surprised or annoyed by the interruption. On his first visit to Glasgow as Prime Minister, a high-level team of officials was at Central Station to greet him. Wilson stepped off the train and, pausing to light his pipe, saw Jim among a group of

pressmen. Ignoring the official party, Wilson strode over to chat to Jim, leaving surprised reporters and photographers gasping.

On another occasion, guiding Margaret Thatcher at one of the many Press Fund charity lunches he organized, Jim told her 'Follow me, hen, and you'll be fine.' The Iron Lady laughed and did as she was told. Jim aimed high when bidding for speakers at Press lunches: Jim Callaghan, John Major, Denis Healy and Tony Blair were among those he barraged with invitations, eventually forcing them to make time in busy schedules. Lord Armstrong, head of the Civil Service and later chairman of Midland Bank, was Jim's cousin.

Healy once joked to an audience of 600 in Glasgow, that the head of the Civil Service in Scotland had one serious disadvantage – he wasn't related to Jim Rodger. Jim even boldy phoned the White House to invite President Bill Clinton to Glasgow and alerted Strathclyde's Special Branch with possible dates. It never happened, but he did try, and Clinton's refusal note was extremely apologetic.

Over a fifty-year period, Jim also took snaps of the famous for fun and it is these, salvaged almost by accident from a cupboard in his home by Tom Purdie, which provide this book's unique and treasured gallery of photographs. They have never been printed before and will surprise and delight players, managers, journalists and, of course, fans.

Wee Jim had a hand in almost every big football deal, but a hitherto unrevealed fact is that wayward Jim Baxter's career might have taken an entirely different course had one of two signing moves come off. Baxter explained: 'In 1963, it was all set up for me to go to Spurs – managed by another of Jim's great mates, Bill Nicholson – but Scot Symon wouldn't let me go. The Spurs boss, I recall, held talks at the Boulevard Hotel. Dave Mackay had broken a leg and Danny Blanchflower was coming towards the end of his career, so he wanted a replacement.

'It was a big disappointment when Spurs were forced to sign Jimmy Robertson from St Mirren. Worse still, Wee Jim told me Helenio Herrera wanted me at Inter Milan. Playing for the Rest of the World team, Denis Law advised me that the discipline in Italy would kill me. I was ready to take the risk, but it never happened, despite Wee Jim's lobbying. I was on £35 a week with Rangers and Denis was on a tenner more at Old Trafford. Italy would have been good for me. On their money, I was ready to grab the chance and play the game on and off the park. I would certainly have had to behave. It could have been the making of me. I'll tell you this – if I'd gone to Milan, I would have been a real star. Instead, they signed Luis Suarez from Barcelona. Without being big-headed, he couldn't have laced my boots, but the next year he was European Player of the Year.'

A year later, Baxter was sold to Sunderland with help from Jim. However, they were a poor side and as Scotland didn't qualify in 1966, he was robbed of his one chance to play in the World Cp finals – to his great regret. Baxter describes the money players recieve now as 'frightening'. He says any player with ability will be a millionaire. But he adds: 'I'm certainly not jealous of them getting huge wages, I just wish I was part of it. When I look back, we really were slaves, but Wee Jim did his best for us. He was a wonderful man and loved helping people.'

Jim really was a legend in his own lifetime. Sandor Barcs, a senior Yugoslav journalist and major figure in European football, once asked him about the legend of the Loch Ness monster, so Jim took him in a *Daily Express* taxi to have a look for himself. Barcs told me he had written a novel about it and a film was to be made in his country. I wonder to this day who they found to play Wee Jim.

When Graeme Souness was manager of Rangers, he called Jim Rodger 'The Godfather'. It was an apt description. Souness says: 'When I was at Ibrox, even if I was on the other side of the world, in my car or at home, Jim would call. He knew everything that was happening and watched my back.'

When he died in January 1997, aged seventy-four, many of the mourners at his funeral

were from the pages of *Who's Who*. They included Sir Alex Ferguson, Sir Bobby Charlton, former Scotland Yard chief Sir David McNee, Graeme Souness, Walter Smith, Kenny Dalglish, Craig Brown, Tommy Burns, John Greig, Ally McCoist, Billy McNeill, Jim Baxter, Joe Jordan and Danny McGrain, to mention just a few. Strathclyde chief constable John Orr joined Labour MPs Helen Liddell and John Reid. Cardinal Ewing, ill with influenza, sent his spokesman, Father Tom Connelly, to represent him.

Jim's impish smile and laughing eyes are captured in a portrait in oils by Robin Miller, which hangs at the Hampden media centre. He seems to be saying to young hacks: 'I know something you don't. It's another exclusive.'

Today, sports writers naturally find it difficult to give credit to the life and times of Jim, who was particularly friendly with Bill Nicholson, Sir Matt Busby, Bill Shankly, Jock Stein and Sir Alex Ferguson. Sir Alex regarded him as a mentor from his boyhood days in Govan and it was no surprise that Jim played a part in his move from St Mirren to Aberdeen. Fergie placed an immense trust in Jim, who regarded him as a family friend. The Dons have never had such success, before or since. The Saints made a mistake in parting with Fergie, and Jim constantly reminded them of this, particularly when, much later, Manchester United also prospered thanks to him.

Think of the unusual and Jim was usually involved. Imagine Rangers' allocation of tickets for a European Cup-tie at White Hart Lane being sent to a reporter's home. That happened during the 1962/63 season – Jim slept with the bundle under his pillow before handing the valuable parcel over at Ibrox.

Jim Rodger was the man behind Dave Mackay's move from Hearts to Spurs in 1958 and, thirty years later, he also arranged for Steve Archibald to go to Spurs. When Kenny Dalglish moved from Celtic to Liverpool for £440,000 – to replace Kevin Keegan, who had left Anfield for SV Hamburg – unsurprisingly, Jim was the middleman. He was also on the inside when Denis Law and Joe Baker were in Italy. Law, Scotland's finest ever striker, said: 'Jim was instrumental in getting me back to United from Turin in 1961. He had so many contacts in the game, it wasn't true. He was the greatest.'

When Alex Scott left Rangers, Jim arranged for him to join Spurs. Bill Nicholson drove with Jim to Ibrox and, confident that the deal was done, he stayed outside but well away from reporters guarding the main door. As Scott went in, reporter Malcolm Munro said rhetorically: 'It's Spurs isn't it, Alex?' The player nodded and walked on. Unknown even to Wee Jim, however, Everton were also outside Ibrox, with a better offer. So the back page of the now-defunct *Evening Citizen* said that Scott would sign for Spurs, while the front page reported that Everton had clinched a deal.

Jim was amusingly secretive. When he tried, unsuccessfully, to get Billy McNeill to Spurs, he gave him a codename, believing that rivals were tapping his telephone. Billy's wife, Liz, thought Jim had got the wrong number when he insisted that he had to speak to Mr Armstrong. Billy had a good laugh, but the transfer never happened.

Rodger worked for the old *Glasgow Evening News*, *Daily Record*, *Daily Express* and *Daily Mirror*, and frequently used his fighting powers on matters which had nothing to do with football. British Rail discovered this when they tried to close the Shotts line. They were derailed by a sustained and blistering Rodger campaign. Had BR done their homework, they would have found out the non-smoking, teetotal, church-going Jim didn't drive and travelled on their trains daily. BR's capitulation was full and almosr immediate. He also fought ferociously to have a waiting-room at the station for rainy days when wives and children were visiting Shotts Prison – where he often arranged for special speakers to interest the inmates.

Jim Baxter summed him up best of all, as a 'wonderful wee man, always trying to help others'. Whether Jim Rodger would have succeeded quite as well in today's high-pressure era of fast-buck agents and enlarged, highly-competitive reporting staffs is another matter.

In his prime there were not nearly as many hacks in opposition and radio and TV hardly bothered him. Now so many are chasing stories in a limited market that one-to-one interviews are rare and personal lunches with players and officials even more unusual. One thing is certain, however: Jim would have given scooping a world exclusive a damned good try.

Alex Cameron

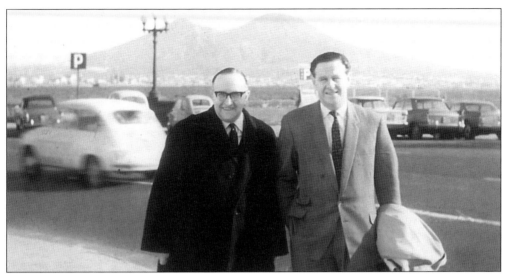

Jim Rodger with Willie Waddell in Naples, prior to Scotland's World cup match against Italy in 1965.

The Scotland team for the international against England at Hampden in April 1960. From left to right, back row: Walker (trainer), McKay (Celtic), Caldow (Rangers), Haffey (Celtic), Cumming (Hearts), Evans (Celtic), McCann (Motherwell). Front row: Leggat (Fulham), Young (Hearts), St John (Motherwell), Law (Manchester City), Weir (Motherwell). Leggat scored in a 1-1 draw.

The Scotland squad in 1960. From left to right: McKay (Celtic), Hunter and St John (Motherwell), Niven (Rangers), Cumming (Hearts), Weir (Motherwell), Herd (Clyde), Gabriel (Dundee), Young (Hearts), Evans (Celtic), Higgins (Hearts), Law (Man City), Leggat (Fulham), and trainer Dawson Walker.

Scotland squad for the game against Uruguay at Hampden in 1962. Scotland lost the match 3-2. From left to right: Wilson (Rangers), Quinn (Motherwell), Hamilton (Dundee), Brand (Rangers), Caldow (Rangers), McKay (Celtic), Scott (Rangers), Connachan (Dunfermline), Crerand (Celtic), Baxter (Rangers), McNeil (Celtic), Ure (Dundee), Divers (Celtic), Ritchie (Rangers).

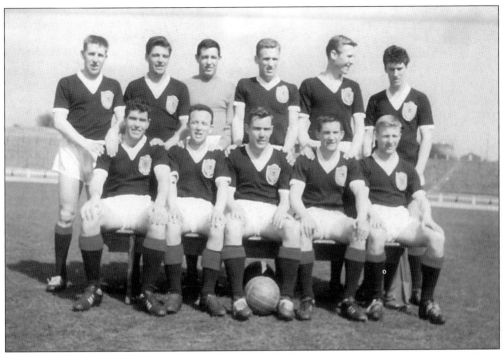

From left to right, back row: Hamilton, Caldow, Connachan, Crerand, McNeil, Baxter. Front row: Scott, Quinn, Mckay, Brand, Wilson.

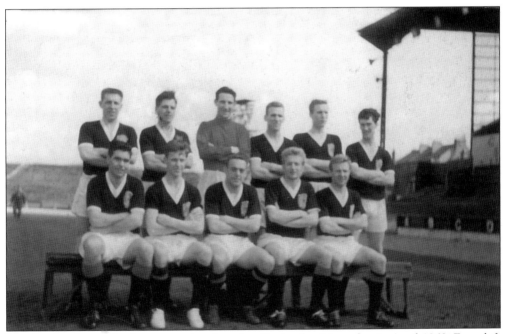

The Scotland team for the international against England at Hampden in April 1962. From left to right, back row: Hamilton (Dundee), Caldow (Rangers), Brown (Spurs), Crerand, McNeil (Celtic), Baxter (Rangers). Front row: Scott (Rangers), White (Spurs), St John (Liverpool), Law (Torino), Wilson (Rangers).

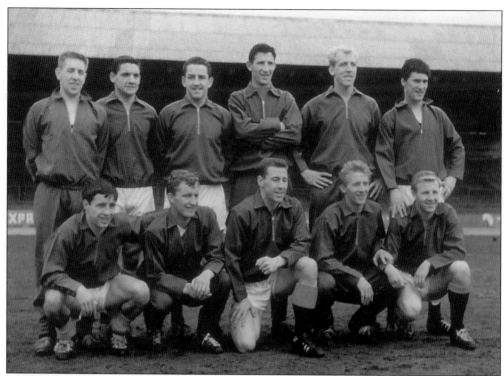

Scotland team for the game against Austria at Hampden in May 1963. From left to right, back row: Hamilton (Dundee), Holt (Hearts), McKay (Spurs), Brown (Spurs), Ure (Dundee), Baxter (Rangers). Front row: Henderson (Rangers), Gibson (Leicester), Millar (Rangers), Law (Manchester United), Wilson (Rangers).

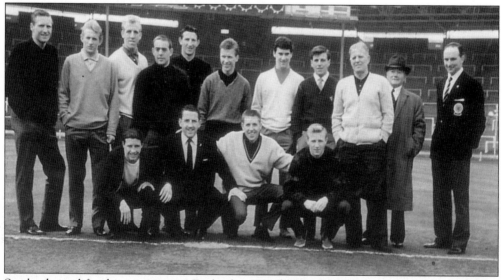

Scotland squad for the game against England at Wembley in 1963. From left to right, back row: McNeil, Law, Ure, St John, Brown, White, Baxter, Caldow, J. Harvey (trainer), J. Terris (SFA), Ian McColl (team manager). Front row: Henderson, McKay, Hamilton, Wilson. Eric Caldow suffered a leg break during the game, but the ten men of Scotland won 2-1.

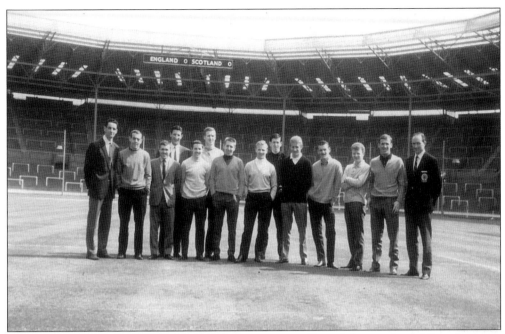

The Scotland squad two years later at the same venue. From left to right: McRae (trainer), St John, Collins, Brown, Henderson, McNeil, Hamilton, Wilson, Greig, Law, McCreadie, Bremner, Crerand, Ian McColl. The game ended in a 2-2 draw.

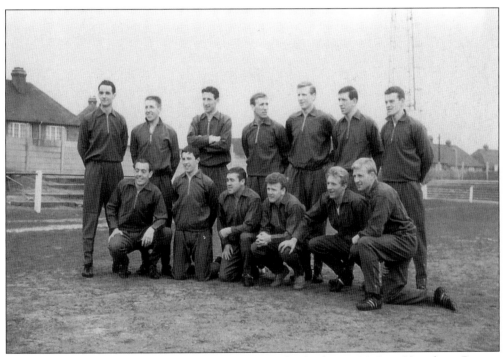

The Scotland squad during training. From left to right, back row: McRae, Hamilton, Brown, Crerand, McNeil, Greig, McCreadie. Front row: St John, Henderson, Collins, Bremner, Law, Wilson.

The Scotland forward line for the game against England in 1965. From left to right: Henderson, Collins, Law, Wilson, St John.

The Scotland forward line for the 2-1 victory over England in 1963. From left to right: Henderson, White, St John, Law, Wilson.

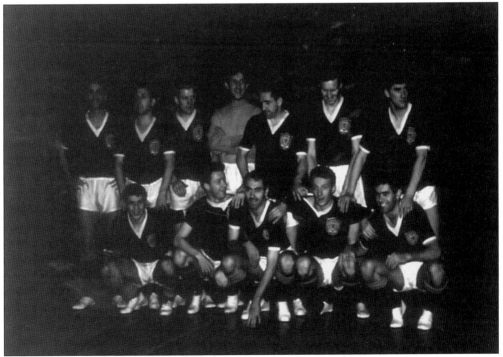

The Scotland squad at training before an international against Wales in 1963. From left to right, back row: McLintock, Hamilton, Kennedy, Brown, McKay, McNeil, Baxter. Front row: Henderson, White, Gilzean, Law, Scott.

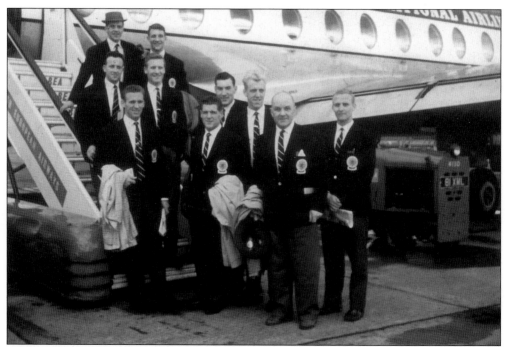

The Scotland squad flying abroad in 1961. From left to right, back row: Caldow (Rangers), David Herd (Arsenal). Middle row: Quinn (Motherwell), McNeil (Celtic), Ogston (Aberdeen), Ure (Dundee). Front row: Crerand (Celtic), Shearer (Rangers), Dawson Walker (trainer), Young (Hearts).

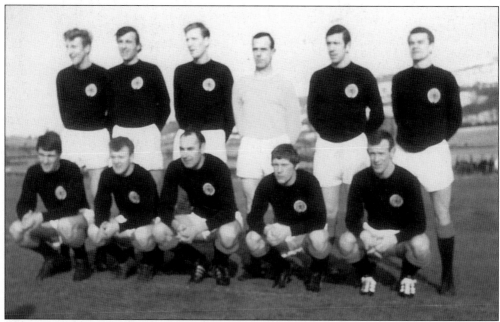

The national side in 1969. From left to right, back row: Gemmell (Celtic), McKinnon (Rangers), McNeil (Celtic), Simpson (Celtic), Greig (Rangers), McCreadie (Chelsea). Front row: Cooke (Chelsea), Bremner (Leeds), Gilzean (Spurs), Johnston (Rangers), Lennox (Celtic).

Billy McNeil, David Herd and Pat Crerand.

Rangers and Scotland full-back Eric Caldow. Eric gained 40 caps for Scotland between 1957 and 1963, at right or left-back. He would probably have made even more international appearances, but a broken leg at Wembley in 1963 finished his international career.

Eric Caldow and Davy Wilson returning to Hampden after a training session.

Bobby Evans of Celtic and Scotland. Bobby gained 48 caps for his country between 1949 and 1960. In 1960, he was transferred to Chelsea and then played for Newport County, Morton and Third Lanark, before finishing his career with Raith Rovers in 1967.

George Herd of Clyde and Scotland. George was capped 5 times for his country between 1958 and 1961. He was transferred to Sunderland in 1961 for a fee of £42,500.

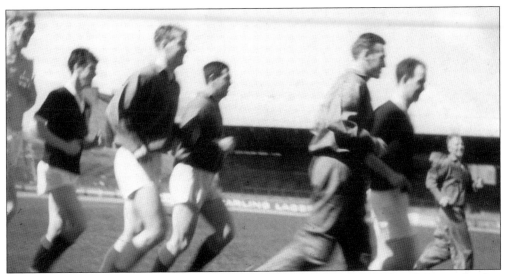

Some of the Scotland squad training at Love Street, Paisley, in 1962. From left to right: Ian Ure, Jim Baxter, Billy Ritchie, Eddie Connachan, Pat Crerand, John Divers, John Harvey.

Bill Brown, of Dundee, Spurs and Scotland, and Frank McLintock of Leicester City, Arsenal and Scotland. Between 1958 and 1966, Bill was selected as goalkeeper for Scotland 28 times. He joined Spurs from Dundee in 1959 for a fee of £16,500. Frank played for his country 9 times, between 1963 and 1971.

Jim Kennedy, of Celtic and Scotland, alongside Jim Baxter. Jim gained 5 caps between 1963 and 1965.

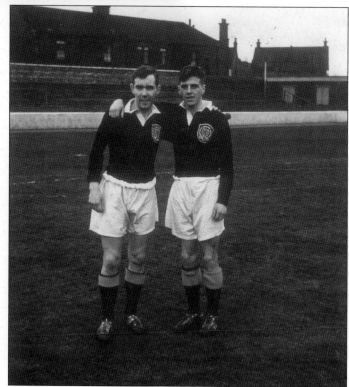

Duncan McKay, of Celtic and Scotland, alongside Eric Caldow. Dunky was capped 14 times for his country between 1959 and 1962, in the right-back position.

John Martis, of Motherwell and Scotland. John was capped once, at centre half against Wales in 1961.

Ian St John, Bert McCann and Andy Weir of Motherwell in training for Scotland in 1960.

From left to right, Alex Young and George Thomson of Hearts, with Davie Kinnear (trainer) and Andy Weir of Motherwell. Young and Thomson later joined Everton.

Willie Hunter, of Motherwell and Scotland. He was capped 3 times at inside left between 1960 and 1961.

Lawrie Leslie, of Airdrie and Scotland. It was while playing for Airdrie in 1961 that the former Hibs goalkeeper won 5 caps. He joined West Ham in June 1961.

Bill Brown
in training.

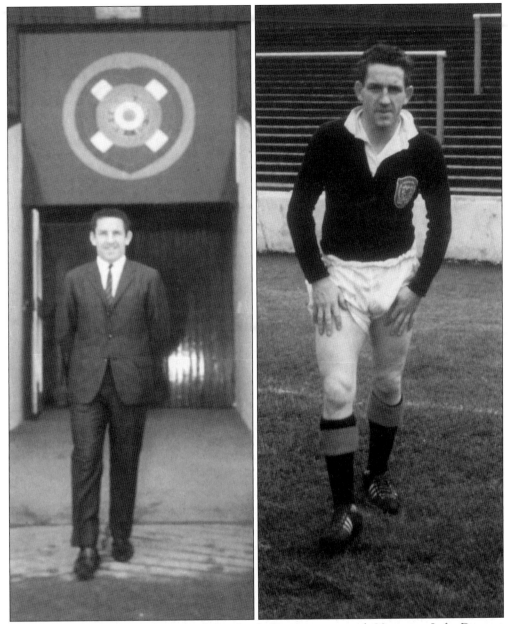

Dave McKay, of Hearts, Spurs and Scotland. Dave was capped 22 times. *Left:* Dave at Tynecastle. *Right:* Dave training with the national side.

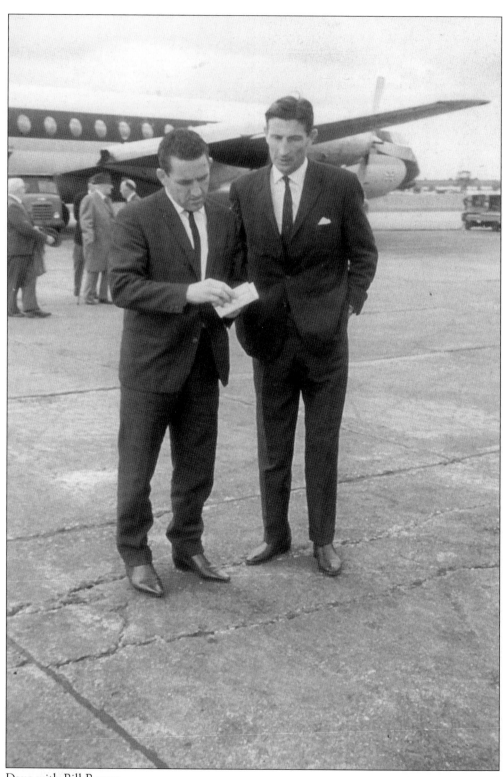

Dave with Bill Brown.

Dave alongside John Harvey at Wembley in 1963.

John Harvey, Scotland's trainer in the early 1960s. John later became manager of Hearts.

John photographed with a trophy, which Hearts had won in the early 1960s while touring in Canada and the United States.

Billy McNeill, of Celtic and Scotland, alongside Davey Hilley of Third Lanark. Billy was capped 29 times for Scotland between 1961 and 1972.

Eddie McCreadie, of Chelsea and Scotland, was capped for Scotland 23 times between 1965 and 1969. Eddie later managed Chelsea, from 1975 till 1977.

Charlie Cooke, of Aberdeen, Dundee, Chelsea and Scotland, gained 16 caps between 1966 and 1975.

Jim McCalliog, of Sheffield Wednesday, Wolves and Scotland. Jim, who was capped 5 times, is pictured with what appears to be two policemen from an Eastern European country.

Jim Baxter Rangers, of Sunderland and Scotland, was capped 34 times.

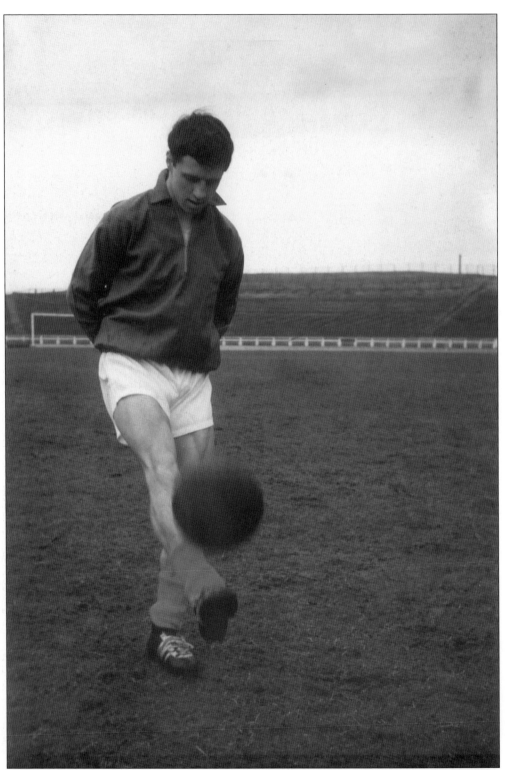

Willie Henderson, of Rangers and Scotland, was capped 29 times.

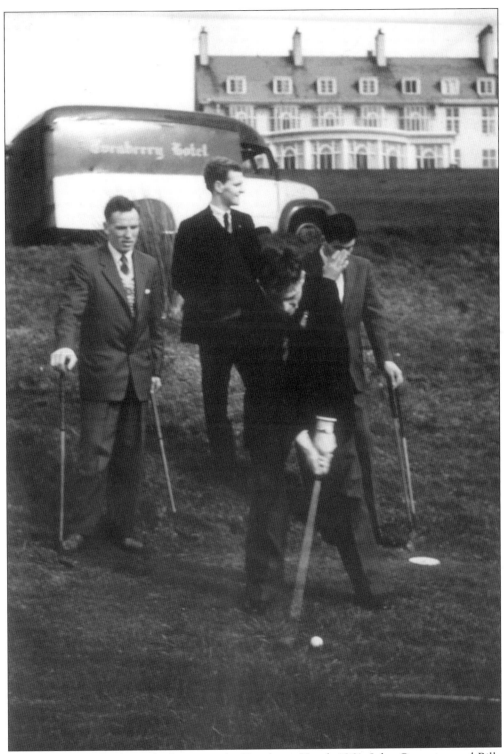

Some of the Scotland squad relaxing at the Turnberry Hotel, 1961. John Cumming and Billy Higgins (both Hearts) are with Eric Caldow (Rangers) and George Herd (Clyde).

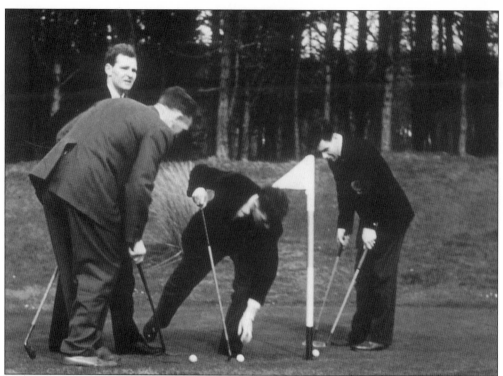

At the same venue are Higgins, Cumming and Caldow, with Alex Scott on the right.

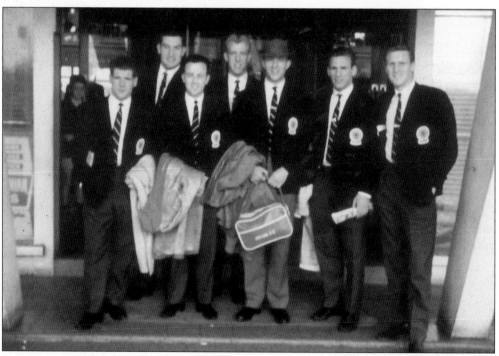

Members of the Scotland squad, 1961. The players shown are Shearer, Ogston, Quinn, Ure, Herd, Crerand and McNeill.

Jimmy Gabriel, of Dundee, Everton and
Scotland, with Eric Caldow.

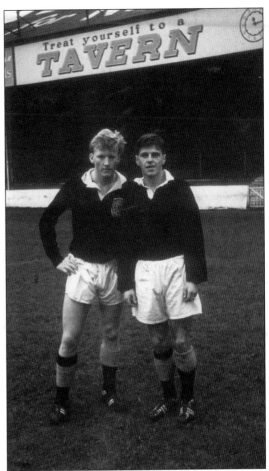

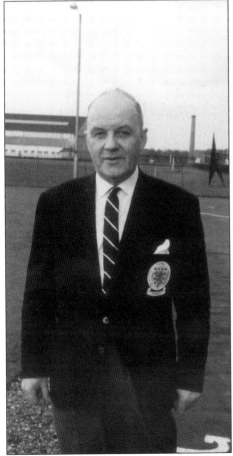

Dawson Walker, who was Scotland's trainer in
the 1950s and early '60s.

Dawson, who was also trainer with Clyde, with Eric Caldow.

Dawson, pictured here with Willie Allan, SFA.

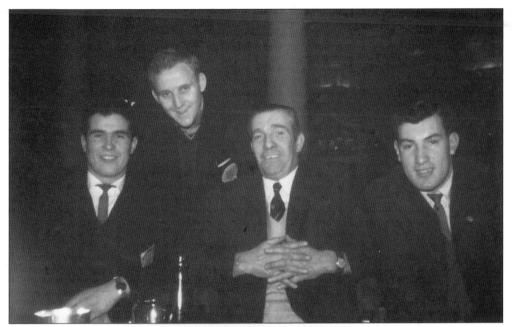

Ron Yeats, Alec Young and Tubby Ogson, with the legendary Dixie Deans.

George Graham, of Chelsea, Arsenal and Manchester United. George was capped 12 times between 1972 and 1973. He was appointed manager of Arsenal in 1986, later managing Leeds and Spurs.

Bert Cromar, of Queens Park. Bert represented his country on many occasions at amateur level.

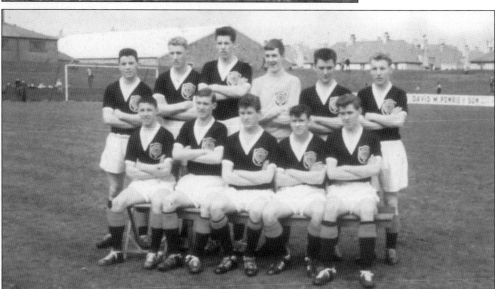

A Scotland youth team at Muirton Park, Perth for a game against Ireland during the 1959/60 season. From left to right, back row: W. Smith, W. Cranston, A. Gray, W. Murdoch, A. King, D. Reid. Front row: W. Henderson, A. Ferguson, G. Fletcher, E. Stevenson, D. Houston.

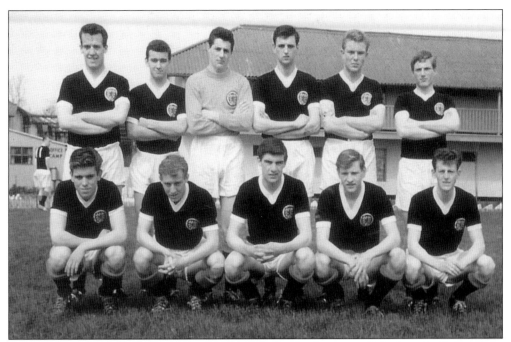

Scotland youth team in the early 1960s. From left to right, back row: J. Parkes, -?-, B. Ferguson, G. Connelly, -?-, H. Quinn. Front row: Edwards, -?-, -?-, -?-, J. Robertson.

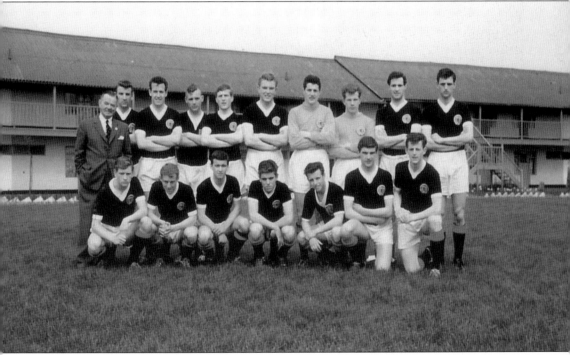

Scotland youth team from around 1962. From left to right, back row: C. Baillie, J. Parkes, J.Towsend, H. Quinn, -?-, B. Ferguson, -?-, G. Graham, G. Connelly. Front row: -?-, -?-, -?-, A. Edwards, T. McLean, -?-, J. Robertson.

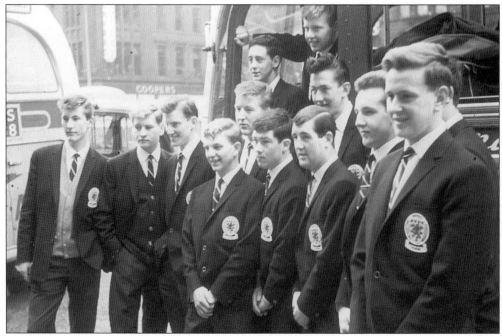

Scotland youth squad, including, from left to right, Bobby Watson (Rangers), Jim Fraser (Dunfermline), Jim O'Rourke (Hibs), Peter McLoy (Motherwell and Rangers) and, in the doorway, Joe Harper (Hibs and Aberdeen).

John Bell and David Holt, both Scotland amateur internationals.

Craig Brown, who was until recently Scotland's coach, photographed outside Ibrox Stadium in 1960.

Scotland youth player, Eric Stevenson.

Eric was part of the Hibs team of the 1960s and early '70s.

George Thompson and Chris Chevlane.

Scotland youth players, John Parkes, Jim Towsend and Colin Baillie.

Scotland youth squad, including Bobby Watson and Jim Fraser (at the back) and Jim O'Rourke (middle of the front row).

Ernie Walker of the SFA.

Jack Mowat, one of the
top referees in football.

To the left of this picture is Bobby Davidson, another top-class referee.

One of Rangers' greatest managers, Scot Symon.

Scot Symon with Oue Gradt.

Symon alongside Rangers director, John Wilson Jnr.

Scot Symon with goalkeeper, Eric Sorenson.

Jimmy Smith and Davie Kinnear of Rangers. Jimmy played from 1928 to 1946 and scored 299 League goals. Later on, he was trainer and chief scout for the club for a number of years. Davie played from 1934 to 1946 and was also trainer from 1956 to 1970.

Joe Craven, the assistant trainer, with Davie Kinnear.

Davie and Joe along with John Wilson Jnr, at the Albion training ground, 1961.

George Young, of Rangers and Scotland. He was capped 53 times between 1947 and 1957 and was a defensive colossus for both his club and country. George later became manager of Third Lanark and was also a hotelier for a number of years.

Alex Scott made his debut for Rangers in March 1955 and scored a hat-trick. In 1963, he left Rangers for Everton and was capped 16 times between 1957 and 1966.

Alex Scott at home with his family.

Rangers winger Davy Wilson, of Rangers and Scotland, complete with bowler hat. Between 1961 and 1965, Davy was capped 22 times. He had joined Rangers in 1956 and left for Dundee United in 1967.

One of the great Rangers legends, John 'Tiger' Shaw, pictured with his wife, Margaret. John played for Rangers from 1938 until he retired in 1954 at the age of forty-two. He was an inspirational captain, who formed part of the famous 'Iron Curtain'.

Jerry Dawson was another Rangers great, who kept goal from 1929 until 1945. He played in goal 271 times for Rangers and had 14 Scotland caps to his credit.

Willie Henderson, of Rangers and Scotland. Willie played for Rangers from 1960 until 1972, when he was transferred to Sheffield Wednesday. Willie played 426 times for Rangers and was capped on 29 occasions.

Henderson on his wedding day.

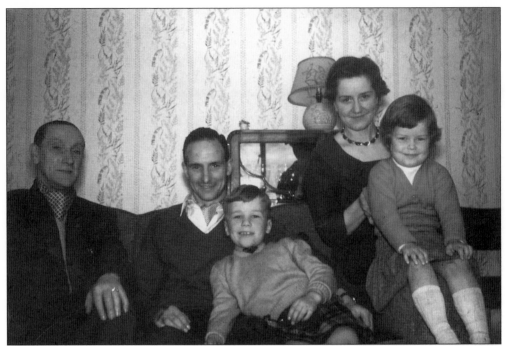

Ian McColl, of Rangers and Scotland, at home with his family, along with director Matt Taylor. Ian's career at Rangers ran from 1945 until 1961, during which time he appeared in a total of 526 games and gained 14 caps.

Rangers chairman, John F. Wilson, along with John Lawrence – who later also became chairman.

Bobby Shearer, Davy Wilson and a pensive-looking Willie Henderson.

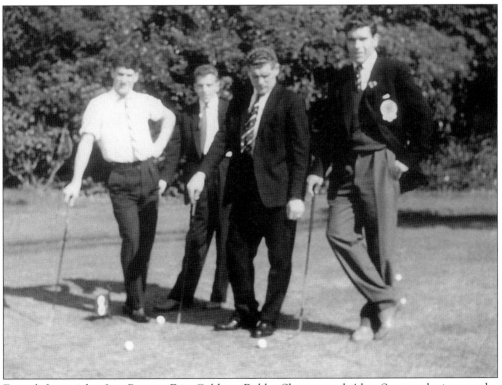

From left to right: Jim Baxter, Eric Caldow, Bobby Shearer and Alex Scott, relaxing on the putting green in 1961.

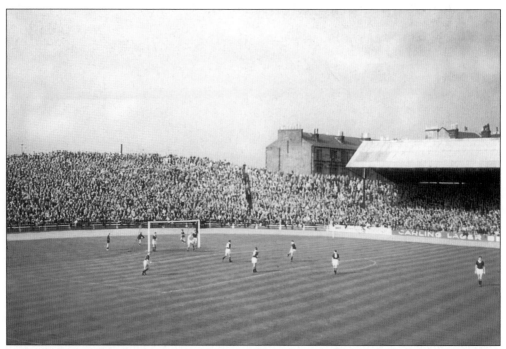

Rangers team warming up at Love Street in 1961.

Rangers and Kilmarnock players at the end of the 1960 Scottish Cup final, which Rangers won 2-0.

A shot of the Rangers *v*. Celtic Scottish Cup final in 1963.

More action from the same game, which ended in a 1-1 draw.

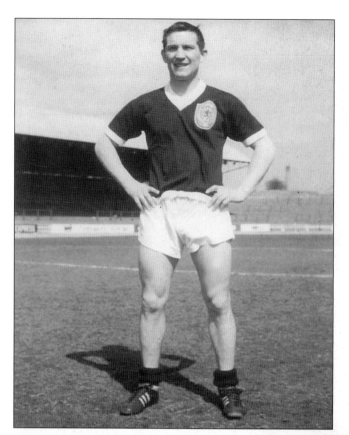

Ralph Brand, of Rangers and Scotland. Ralph formed a deadly partnership with Jimmy Millar in the early 1960s. He was signed in 1954 and played 317 games before leaving for Manchester City in 1965, having been capped 8 times for his country.

Jimmy Millar was the other half of the 'M' and 'B' partnership, which helped Rangers dominate in the early 1960s. He played 317 games and scoring 162 goals for the club. This photograph shows Bobby Shearer and Jimmy Millar with the then manager of the Gleneagles Hotel. Bobby spent ten years at Ibrox, appearing 407 times in the 'light blue' and gaining 4 Scotland caps.

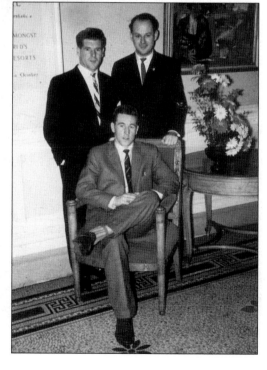

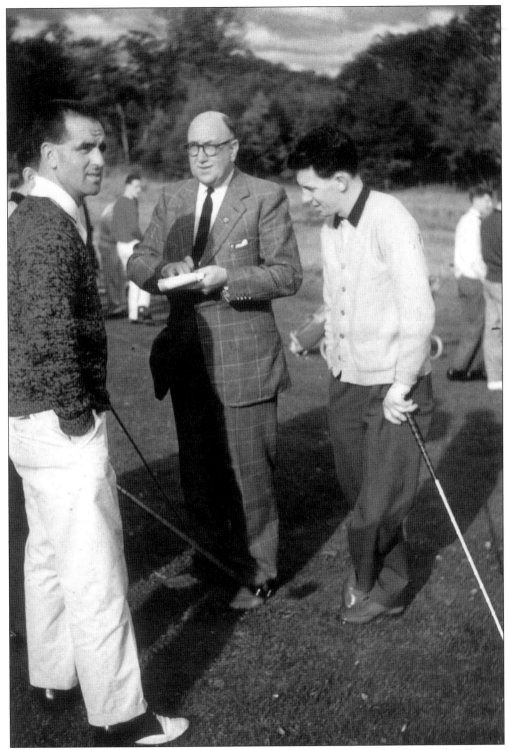

Max Murray, to the right of the photograph, was the scorer of Rangers' first ever goal in Europe. He was at Ibrox from 1955 to 1963 and scored 121 goals in 154 appearances.

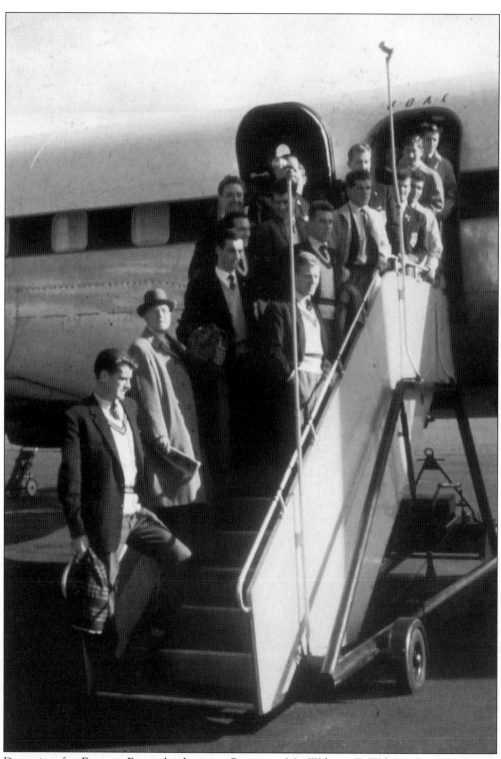

Departing for Europe. From the bottom: Paterson, Mr Wilson, D.Wilson, Provan, Brand, Millar, Hume, Franks, Shearer, McMillan, Scott, Ritchie, Niven and Caldow.

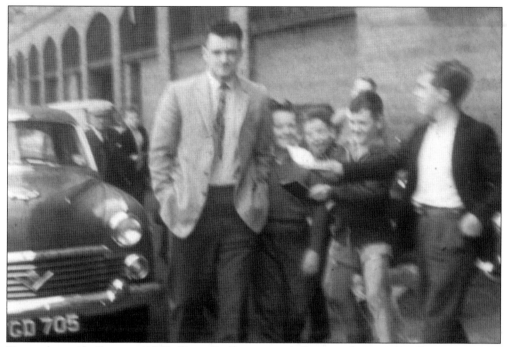

Pictured outside Ibrox in 1960, Doug Baillie was with Rangers from 1960 till 1964. He was signed from Airdrie for a fee of £16,000.

Doug left for Third Lanark in 1964. He is now a sports journalist.

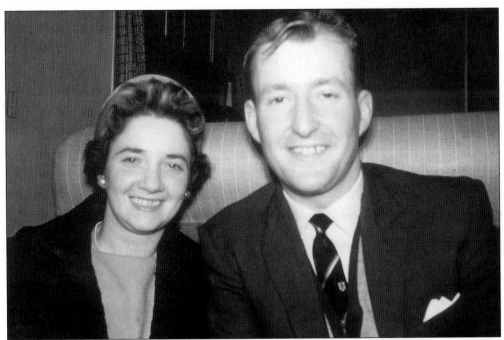

Billy Ritchie kept goal for Rangers on 340 occasions between 1955 and 1967, when he left for Partick Thistle.

Billy after an injury sustained against Hearts in 1960.

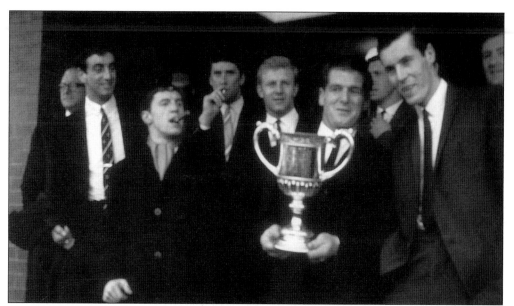

Rangers with the Scottish Cup at Hampden in 1964. From left to right: Provan, Henderson, Baxter, Wilson, Shearer, Greig, McLean, Ritchie.

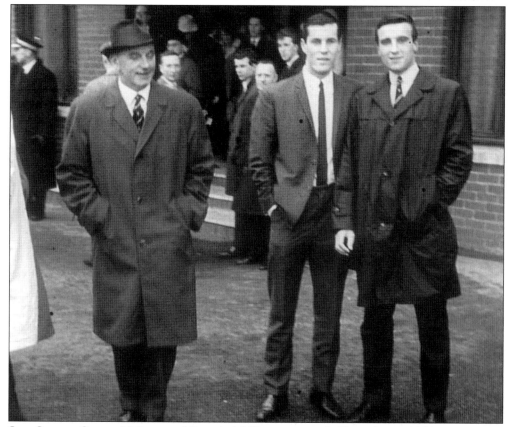

Scot Symon, George McLean and Ronnie McKinnon, outside Hampden in 1964.

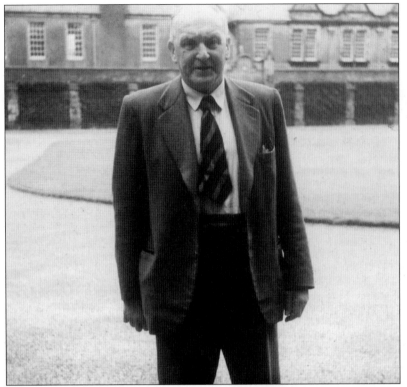

Andy Cunningham, inside forward for Rangers between 1915 and 1929, gained 12 Scottish caps.

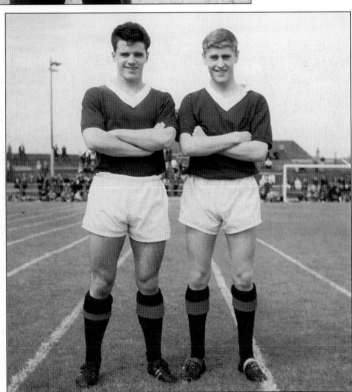

Footballing cousins, Jim Forrest and Alex Willoughby, at Brockville, Falkirk in June 1962.

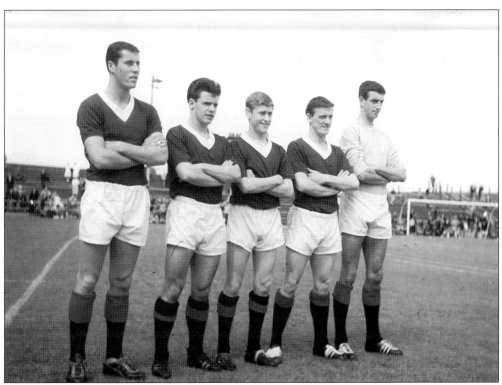

Rangers five-a-side team at Brockville, from left to right: McLean, Forrest, Willoughby, Watson, Davie Provan (who was goalkeeper for the day).

Jim Forrest and Alex Willoughby at a Boys Brigade/Lifebuoys meeting.

A bowler-hatted Willie Allison, Rangers' public relations officer, outside Celtic Park.

Jim Baxter signed for Rangers from Raith Rovers in 1960 and remained there until 1965, when he was transferred to Sunderland.

Jim was always one of the 'jet-set'.

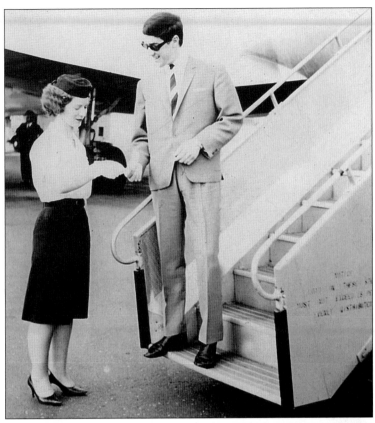

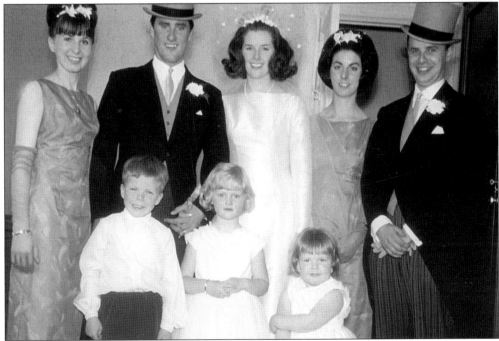

Baxter on his wedding day. His best man was sports journalist Rodger Baillie.

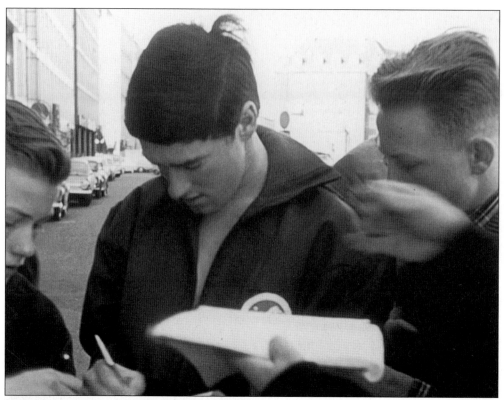

Jim was always surrounded by autograph hunters.

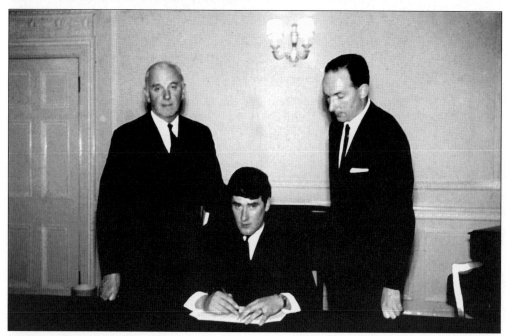

Baxter, with Scot Symon and Sunderland manager Ian McColl on either side of him, signs for Sunderland for £72,500 on 25 May 1965.

The signing took place in a hotel in Edinburgh and Baxter's debut for Sunderland was in a pre-season friendly against Celtic at Roker Park.

Jim with his wife, Jean.

Jim with his first-born son, Allan.

Jim Baxter and Craig Watson with their wives.

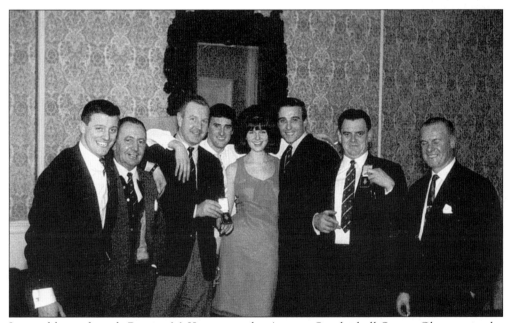

Jim and his wife with Ronnie McKinnon at the Astoria, Sauchiehall Street, Glasgow, in the early 1960s.

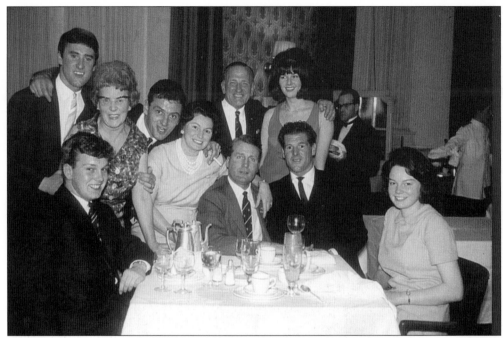

A Rangers function with Jim Baxter, Doug Baillie, Joe Craven, Davie Kinnear and Bobby Shearer in the group.

Jim Christie was a centre forward who joined Rangers from Ayr United in May 1961. In his three seasons at Ibrox, he only made a handful of first-team appearancess.

Jimmy Millar, Alec Smith and John Greig outside Ibrox in 1966.

Smith had recently joined Rangers from Dunfermline for a fee of £35,000.

Players at Ibrox in 1966. From left to right: Jimmy Millar, Wilson Wood, Bobby Watson, George McLean, Alec Smith.

Alec Smith and George McLean. In 1963, McLean signed for Rangers from St Mirren for a then Scottish record transfer fee of £27,500. He left in 1967 for Dundee, after a defeat by Berwick Rangers effectively finished his Ibrox career. After leaving Dundee, George played for Ayr United.

Rangers squad at Abbotsinch Airport, Glasgow. From left to right, back row: Andy Penman, Bobby Seith, Bobby Watson, Roger Hynd, Billy Ritchie, Sandy Jardine, Dave Smith, Alec Smith, Alex Ferguson, Kai Johansen, Eric Sorenson, Dave White, Ronnie McKinnon, Willie Johnston. Front row: Davie Provan.

A none-too-confident-looking Willie Henderson on horseback.

Bill Nicholson, the Spurs manager, and Scot Symon, with their wives.

Ibrox Stadium, 1961.

Finlay McGilvaray, who signed
for Rangers from Third Lanark,
pictured at Cathkin.

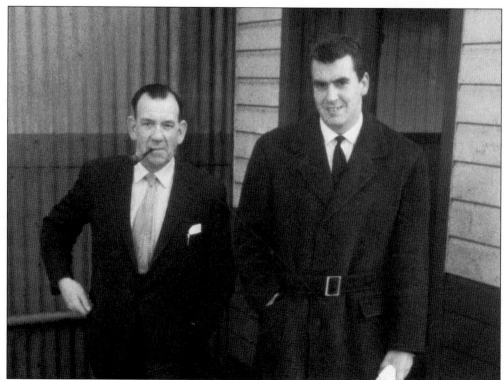

Jimmy McGrory, complete with pipe, outside Celtic Park with John Colrain, *c.* 1960. Jimmy served Celtic as a player from 1922 to 1937. After a time as manager of Kilmarnock, he returned to Celtic in 1945 as manager until the arrival of Jock Stein in 1965. McGrory was then appointed public relations officer.

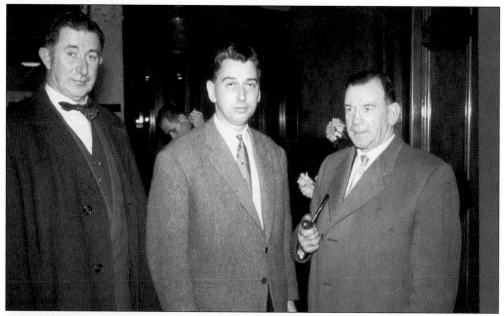

Desmond White, Celtic director, on the left, with McGrory on the right of the picture.

Sean Fallon at Celtic Park in 1960. Sean joined Celtic in 1950 and served as a player, assistant manager, acting manager and scout until 1978.

John McPhail and Sean Fallon at Celtic Park in 1960. John McPhail had a long, distinguished career with Celtic from 1941 till 1956 and was capped on 5 occasions for Scotland. He scored the only goal of the game in Celtic's 1951 Scottish Cup final win over Motherwell.

John Colrain, Sean Fallon and Pat Crerand at Celtic Park in 1960. Colrain later left Celtic for Clyde, while Crerand was transferred to Manchester United in 1963. Between 1961 and 1966, Pat was capped 16 times for Scotland.

Matt McVittie,
John Colrain,
Pat Crerand
and Sean
Fallon.

John McPhail and Charlie Tully, photographed in Argyle Street, Glasgow. Charlie Tully joined Celtic in 1948 and made his debut that year against Morton. He left Celtic in 1959 to become player-manager with Cork Hibs.

Charlie Tully and John McPhail, with people who are thought to be officials from Shamrock Rovers Football Club.

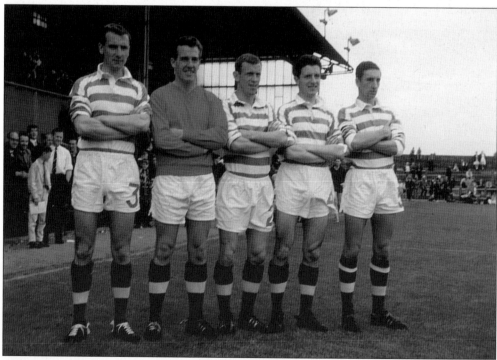

Celtic five-a-side team at Brockville, Falkirk, June 1962. From left to right: Willie O'Neil, John Parkes, Bobby Lennox, Charlie Gallacher, Frank Brogan.

*Left:* A Celtic training session in 1961, led by Duncan McKay, followed by John Divers and Willie Fernie. *Right:* Stevie Chalmers leads the line with John Hughes behind him.

Celtic players enjoying a break, *c.* 1962. From left to right: John Cushley, John Parkes, Bobby Murdoch, Frank Brogan, John McNamee, Willie O'Neill.

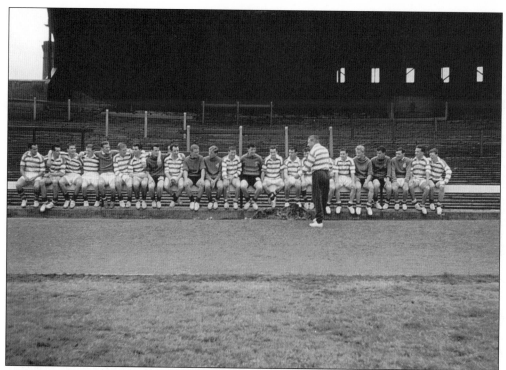

A Celtic squad being spoken to by Bobby Rooney in 1961. From left to right: Fernie, -?- , McNamee, Kennedy, Crerand, McNeil, Hughes, -?- , Divers, -?- , -?- , -?- , -?- , Chalmers, Byrne, -?- , Carroll, -?-, -?- , Cushley, McKay, Clark, Fallon.

From left to right: Frank Haffey, Billy McNeil, Billy Price, Jim Kennedy.

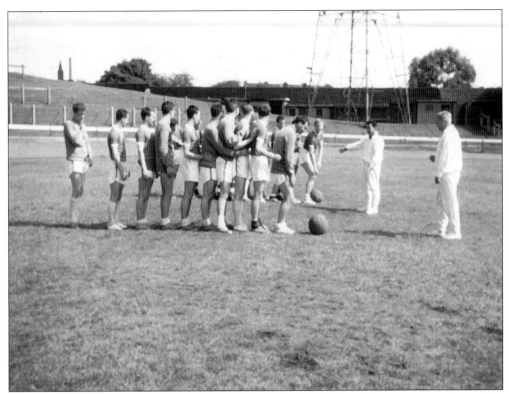

Sean Fallon and Bobby Rooney with the squad, which includes a youthful-looking Billy McNeill to Fallon's left.

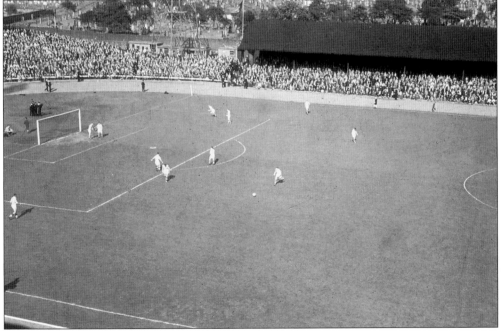

A view from the press box at Celtic Park, with the team warming up.

John Hughes, of Celtic and Scotland. John joined Celtic in 1959 from Shotts Bon Accord and made his debut in August 1960 against Third Lanark. He was capped 8 times for Scotland and left Celtic Park in 1971 for Crystal Palace.

Jimmy Johnstone with air hostesses, *c.* 1964. This is an unusual photograph of 'Jinky' – his fear of flying was well known.

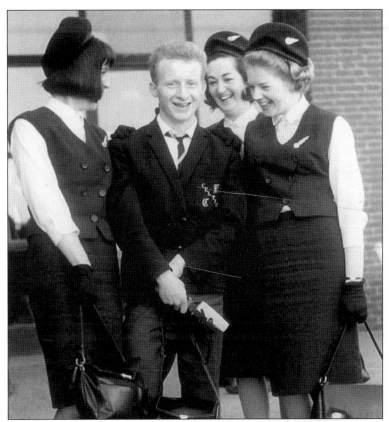

Jimmy at the same venue.

Jimmy with fiancée Agnes Docherty. 'Jinky' joined Celtic in 1961 and made his debut in 1963. He left Celtic in 1975 and, after a short spell in USA, played for Sheffield United and Dundee.

The Celtic squad arriving home from Europe. Jim Kennedy is being followed by John Clark, Ronnie Simpson and John Fallon.

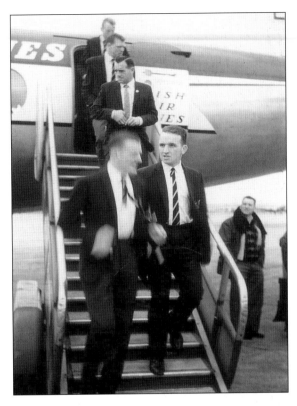

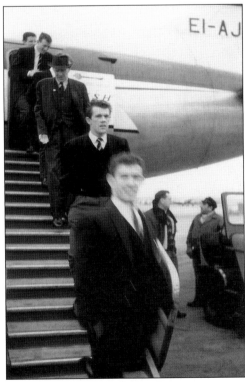

John Cushley, Ian Young, Sir Bobby Kelly and Bobby Lennox.

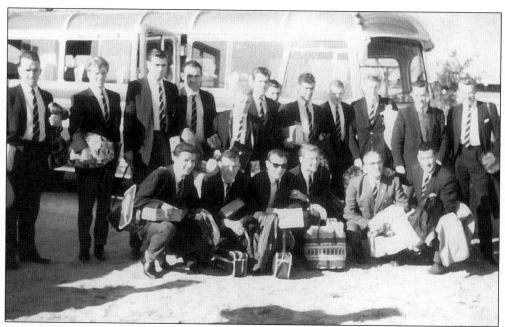

Celtic in Barcelona for a Cup Winners Cup match in 1964. From left to right, back row: Clark, Cattenach, Hughes, Divers, Johnstone, Young, Cushley, Kennedy, Gemmel, Chalmers, Maxwell. Front row: Gallacher, Lennox, O'Neill, McNeil, Mr Fitzimmons, Sean Fallon.

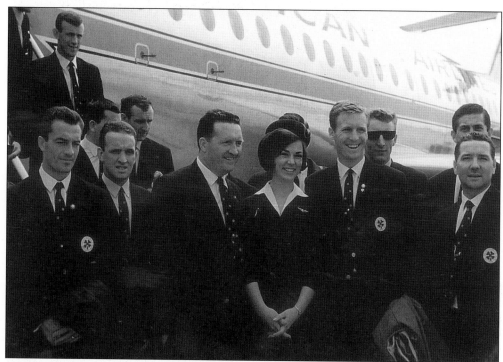

Celtic embarking on a tour of the USA. From left to right, behind: Bobby Lennox, Willie O'Neill, Joe McBride. Front: Bertie Auld, Stevie Chalmers, John Clark, Jock Stein, Billy McNeil, Tommy Gemmel, Frank McCarron, Neil Mochan.

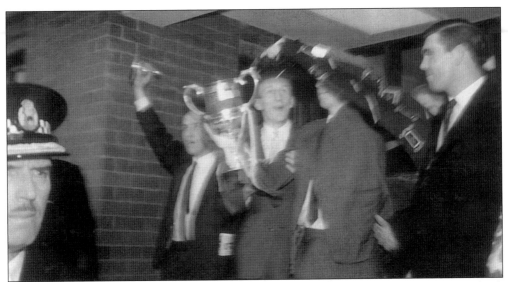

Players at Hampden after Celtic's 3-2 win over Dunfermline in the 1965 Scottish Cup final. From left to right: John Clark, Tommy Gemmel, John Hughes.

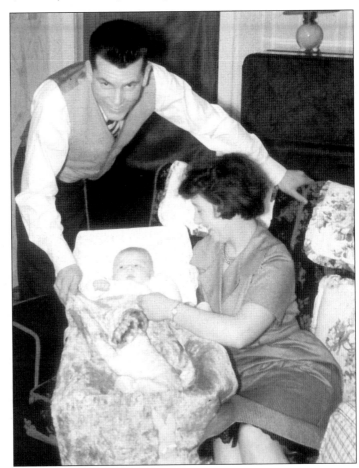

Joe McBride and family. Joe was Jock Stein's first signing for Celtic, arriving in June 1965 from Motherwell. He scored 86 goals in 94 appearances for the club, before joining Hibs in October 1968.

Mr Cribben with John McPhail.

Pat Crerand with the memorial to John Thompson.

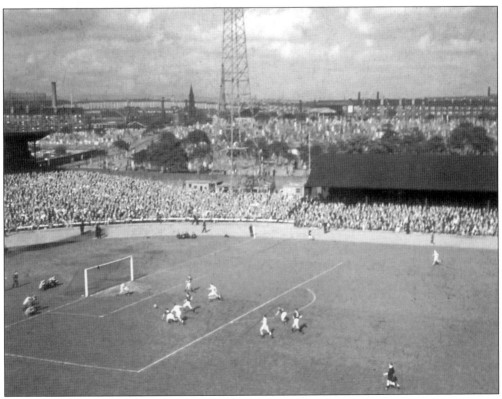

A view of Parkhead during a game against Rangers in 1961.

The same game, showing the traditional Rangers end.

A view of the old 'Jungle'.

Mrs Stein, with Bertie Auld to the right of the picture.

Stevie Chalmers in training. He was capped 5 times for Scotland.

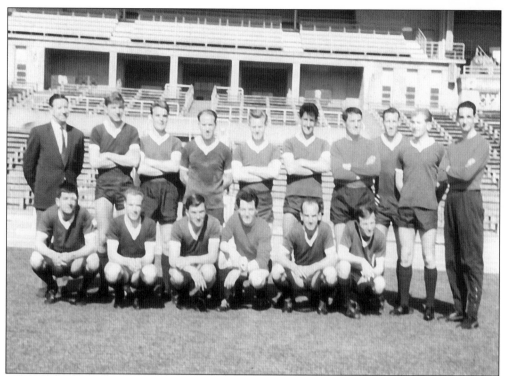

The Kilmarnock squad for their Fair Cities game against Eintracht Frankfurt in Germany. From left to right, back row: Willie Waddell, McFadzean, -?- , Watson, Murray, Beattie, Forsyth, McInally, McGrory, McRae (trainer). Front row: Brown, Black, King, McLaughlin, Sneddon, McIlroy.

Some of the team in training.

Kilmarnock full-back, Matt Watson.

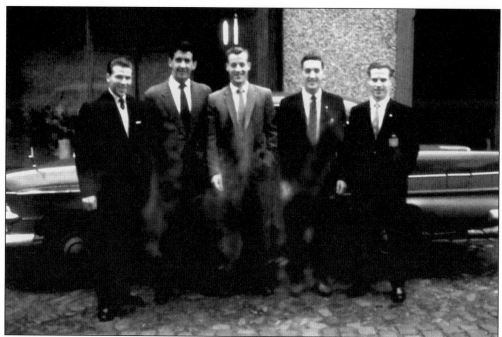

Several Kilmarnock players in the 1960s. From left to right: Kenney, Beattie, Richmond, Stewart, Black.

Davie Sneddon with the *Daily Record* Golf Trophy, Kilmarnock, 1964. Alongside him are Jacky McInally, Frank Beattie, Campbell Forsyth, Joe Mason and journalist Hugh Taylor.

Davie Sneddon.

Two Kilmarnock favourites – Bertie Black and Andy Kerr – outside Rugby Park in 1960.

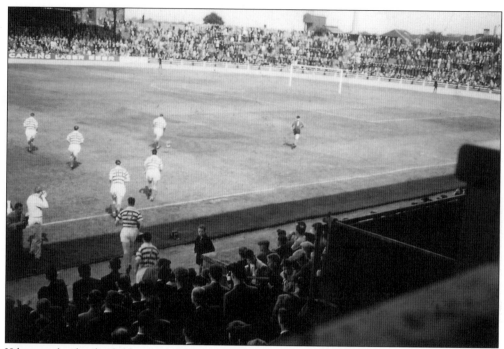

Kilmarnock take the field at Love Street in 1961.

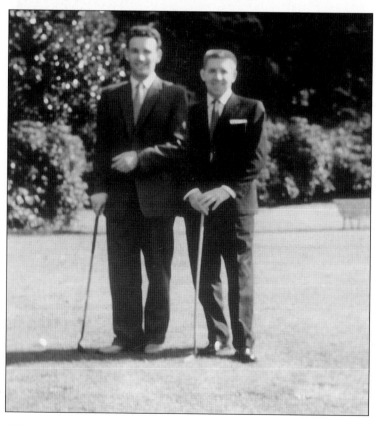

Bobby Seith and Alex
Hamilton of Dundee.

Dave McKay, Alec Little (journalist) and Danny Blanchflower.

Blanchflower
and McKay on
the golf course.

Danny Blanchflower of Spurs.

Ian Ure signing for Arsenal from Dundee in August 1963, for a fee of £62,500. Billy Wright and Bob Ancell are looking on. Ure played for Arsenal until 1969, when he was transferred to Manchester United in an £80,000 deal. He was capped 11 times for Scotland.

Joe Baker and Denis Law. Both players were signed by Torino, Italy, in June 1961.

Pictured in the middle of the photograph is Gigi Peronace, the Italian who was responsible for signing the two players. Law is on the left and Baker is second from right.

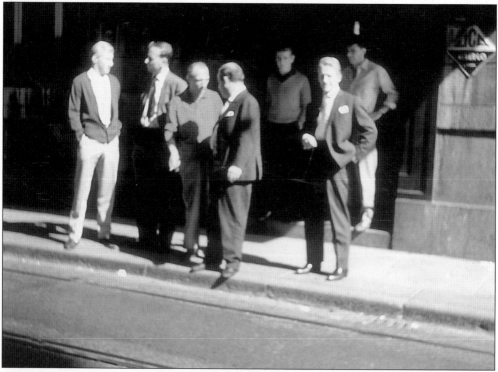

Pictured in Turin, Law is to the left and Baker is fifth from the left of the photograph.

Denis Law with one of the Italians.

Denis Law, whose career included spells at Huddersfield Town and Manchester United, was capped 55 times for Scotland between 1959 and 1974. He retired in 1974 after a season with Manchester City.

Joe Baker in Turin, 1961. Joe began his career with Hibs and, after a short spell in Italy, returned to Britain to sign for Arsenal.

Joe Baker at Shotts railway station.

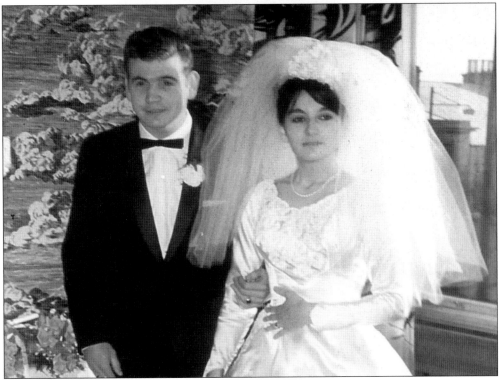

Joe on his wedding day.

Denis Law with the legendary Ferenc Puskas.

Denis Law (centre) with Jimmy Greaves.

Gerry Baker, brother of Joe. Gerry played with Motherwell, St Mirren and Hibs. He won a Scottish Cup medal with St Mirren in 1959.

Gerry Hitchens (Inter Milan), John Charles (Juventus), Law and Baker prior to an Italian League against a Scottish League match at Hampden Park during the 1961/62 season.

Training at Lesser Hampden.

John Charles, who was also a Welsh internationalist.

Alfredo Di Stefano, Real Madrid.

Di Stefano sight-
seeing in Scotland.

Ferenc Puskas with the European Cup.

Puskas outside the Marine Hotel.

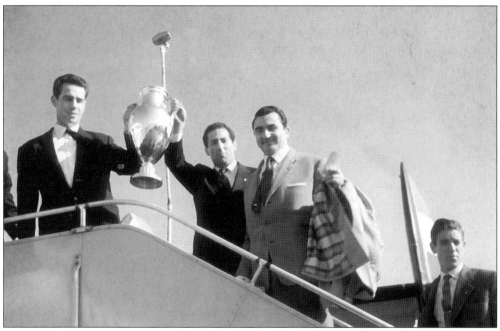

Real Madrid defeated Eintracht 7-3 on 18 May 1960 at Hampden.

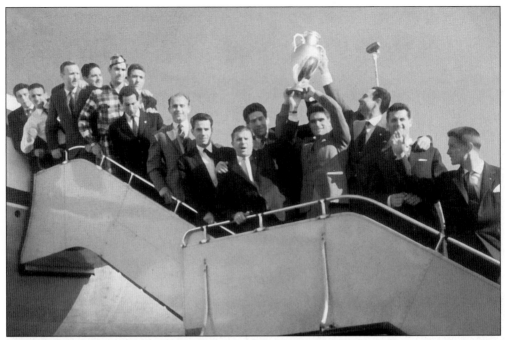

Real Madrid returning home with the European Cup.

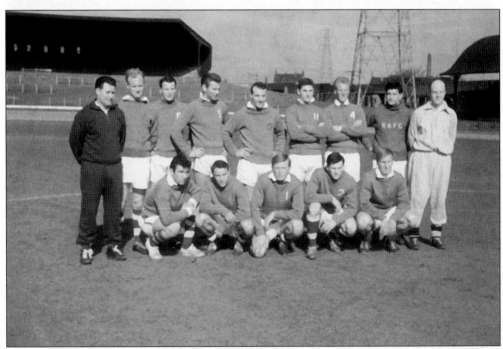

The English League team photographed at Celtic Park before a game against the Scottish League at Ibrox in 1961. From left to right, back row: Harold Sheperdson, Howe (West Brom), Robson (West Brom), Swan (Sheffield Wednesday), Springett (Sheffield Wednesday), -?-, Flowers (Wolves), -?-, -?-. Front row: Brabrook (Chelsea), Greaves (Chelsea), Hitchins (Aston Villa), Fantam (Sheffield Wednesday), Charlton (Manchester United).

Bobby Charlton with the ball during the England training session.

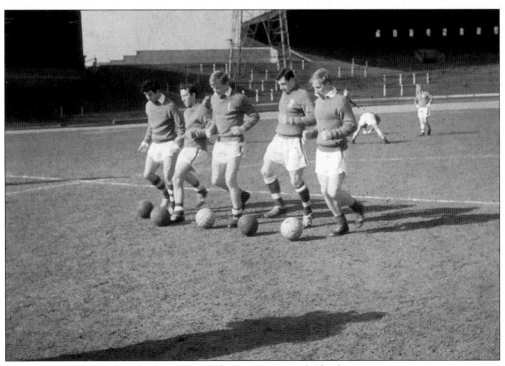

From left to right: Brabrook, Greaves, Hitchins, Fantam and Charlton.

Fantam and Greaves, wearing Celtic colours.

Johnny Haynes, of Fulham and England.

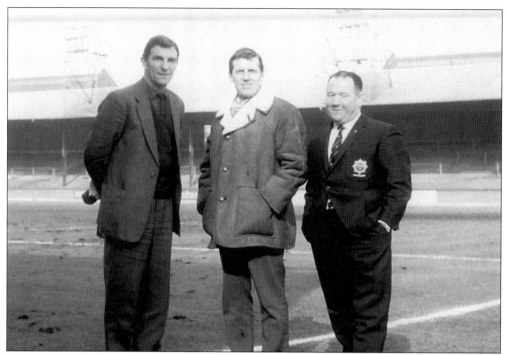

Doug Cowie, Bobby Howitt and John Ellis at Cappielow Park, Greenock, *c.* 1963.

Bobby Howitt
and John Ellis.
Bobby later
became manager
of Motherwell.

Bill Shankley (wearing hat) and Rueben Bennet of Liverpool.

Photographed in Spain in 1967/68. From left to right: journalists Willie Waddell and John McKenzie, Davie White (the Rangers manager), Drew Rennie, Hugh Taylor and James Sanderson.

The Motherwell team with the Summer Cup in 1965. From left to right, standing: Bobby Howitt, Murray, McCallum, Thomson, Weir, McLoy, Delanay, Lindsay, Martis. Kneeling: Joe McBride.

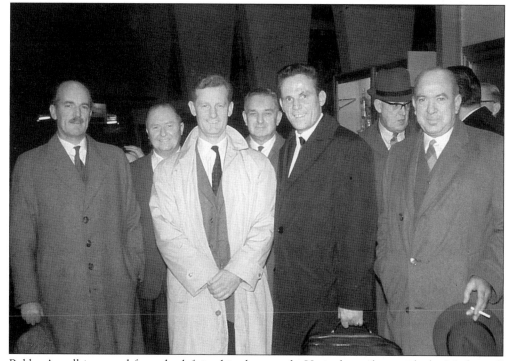

Bobby Ancell is second from the left in this photograph. He is shown here with the Motherwell directors.

Bert McCann, of Motherwell and Scotland. He was capped 5 times between 1959 and 1961. A schoolmaster by profession, Bert was a graduate of Edinburgh University.

Four Motherwell stalwarts – Andy Paton, Bobby McPhee, Pat Quinn and Willie McSeveney.

Arsenal players at Turnberry Hotel. Tommy Docherty (seated) is flanked by George Eastham and David Herd, with Jackie Henderson (at the back, on the right).

Full time in the 1962 League Cup final between Hearts and Kilmarnock.

Jacky Cox, the former manager of St Mirren.

Sports writer Rex Kingsley, who was well known for his column in the *Sunday Mail*, 'The Rex Angle'.